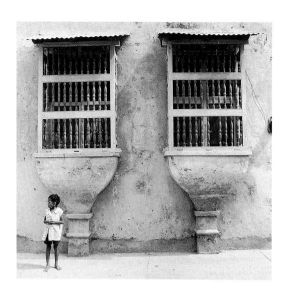

Book created, developed and edited
in Colombia by
VILLEGAS ASOCIADOS S. A.
Avenida 82 No. 11-50, Interior 3
Bogotá, D.C., Colombia
Telephone (57-1) 616 1788. Fax (57-1) 6160020
e-mail: informacion@VillegasEditores.com

First English edition,
november, 1995

First reprint,
november, 2002

ISBN
958-9393-16-0

VillegasEditores.com

CARTAGENA
forever

Photography
**HERNAN
DIAZ**

Villegas
editores

To walk once again through Cartagena, to feel her salt on the skin and the sweet aroma of coconut rice on the corners. Beyond the sunsets, and the sand of the beaches, beyond even — a little further past — the city walls, past San Felipe de Barajas, La Popa, beneath the balconies of San Pedro, near the macaws and the palms swaying in the evening breeze at six o'clock, close to so many people, in the cry of the fresh fruit vendor which breaks the silence, with every street, every arch, every church, every patio, every tower with its bell, every woman with her petticoats, every girl with her smile, every child with his candied coconut or his ice lolly; in all of this, at the edge of all of this, sparkles the essence of the city like a blazing light, emitting radiance which returns once again here on this table, in this book, with that secret syllable, deep within these photographs, beneath the overwhelming sensation that it is impossible to capture in a single word, unless that word says what it has to say; for example, Cartagena de Indias.

Cartagena speaks to each of us the language of deep things, of essences and transparencies, of memories, of wonder. Someone was once here, someone wasn't, someone took him by the hand, in this place he felt his skin tingle, the light, the feeling of being alive, someone crossed this doorway, strolled along this wall, felt the dampness of the stone against the palm of the hand, someone crossed the square, wandered through this landscape until getting lost, someone sat at night at this open-air stall, someone left weariness in this gesture, someone split into two until finding himself, until shaking his own hand, until seeing himself with different eyes, until leaving himself abandoned forever, here in the shade of this noon.

So one day Hernán Díaz invented Cartagena and pursued this calling forever. But he was able to give to this invention the marvellous touch of the true artist. In such a way that in this chequered dress, in this gesture, in this wide-brimmed hat, in this kiss, in this crumbling wall, there is our own invention, it is me, it is you, it is the one from beyond, it is the black woman in curlers, and the little boy in shorts who make this place, who today invent —and will invent tomorrow— a different Cartagena, which, mysteriously, will be the same Cartagena of yesterday, everybody's Cartagena, *Cartagena Forever*.

BENJAMIN VILLEGAS

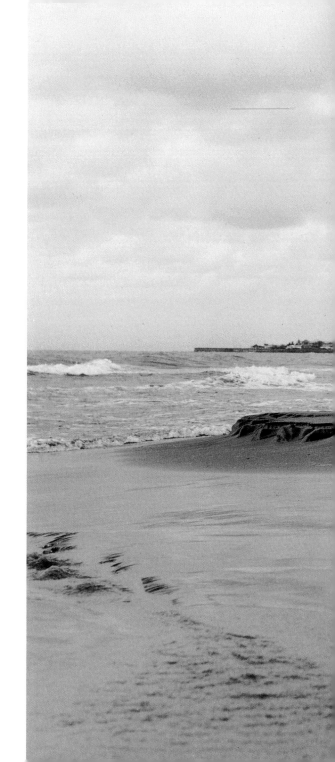

Bocagrande beach.

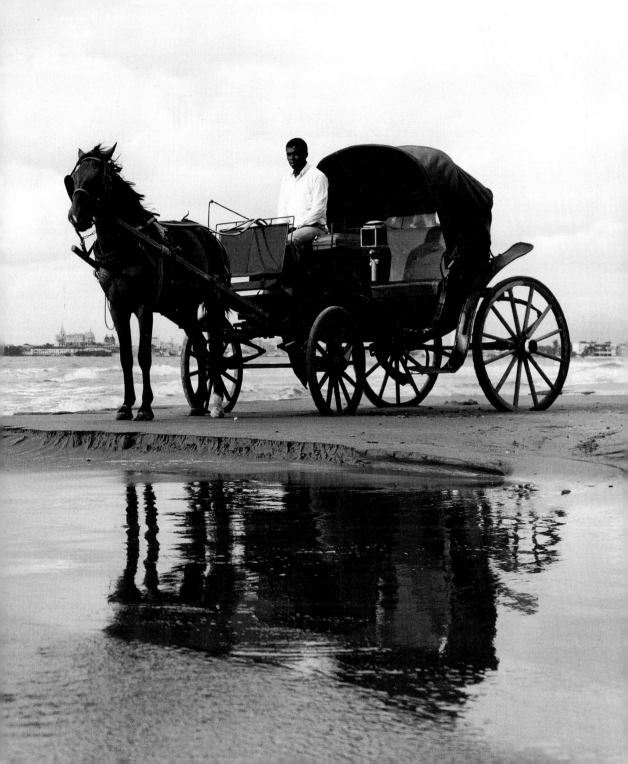

*San Fernando de Bocachica,
the Sharks' Pit.*

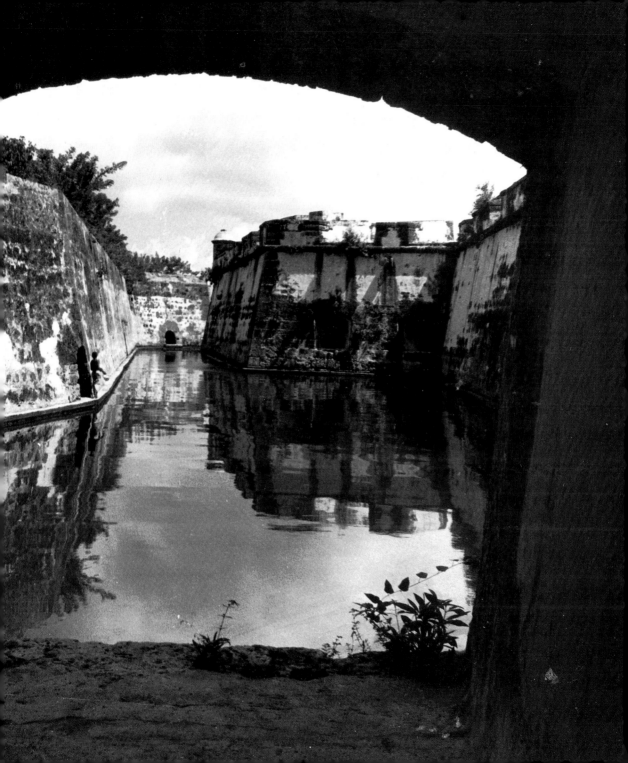

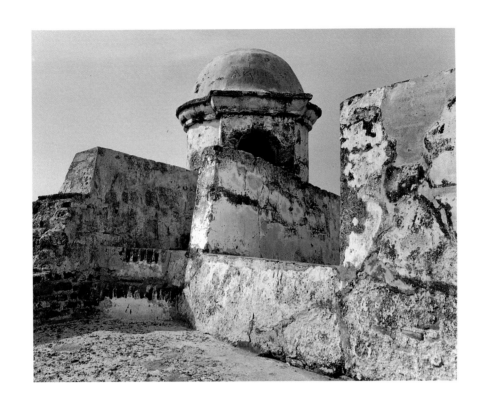

Minarete de la tenaza.

An inviting entrance in the fortified walls.

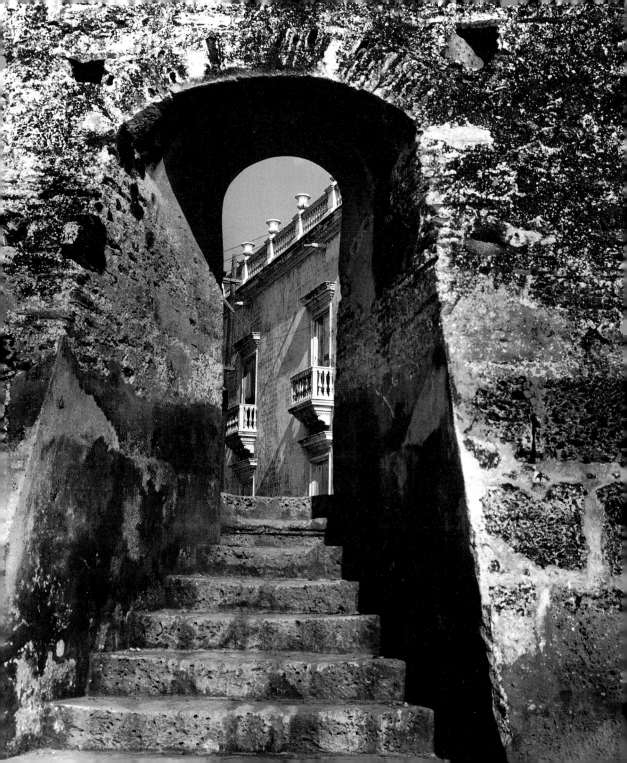

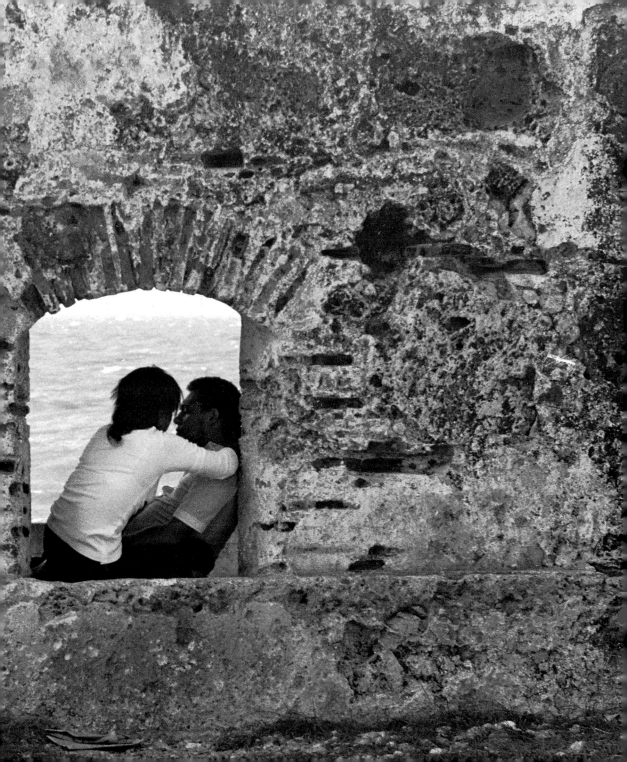

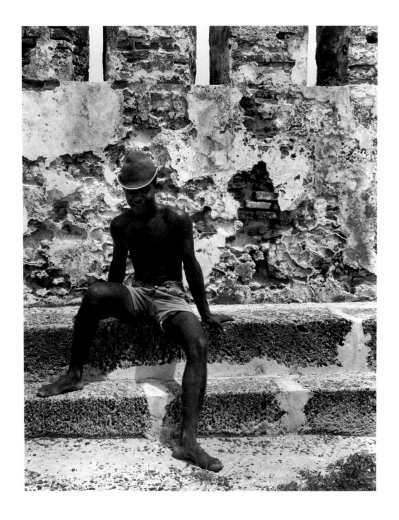

On the Tenaza de Santa Catalina.

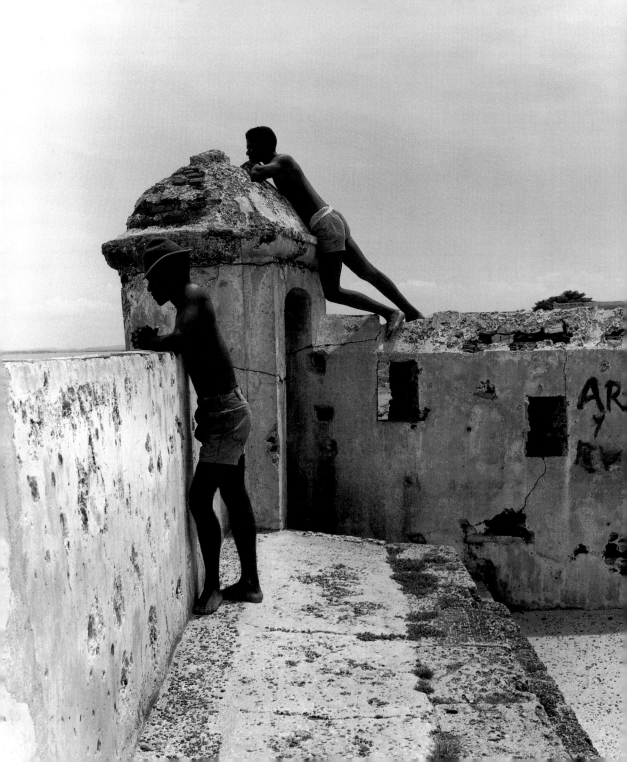

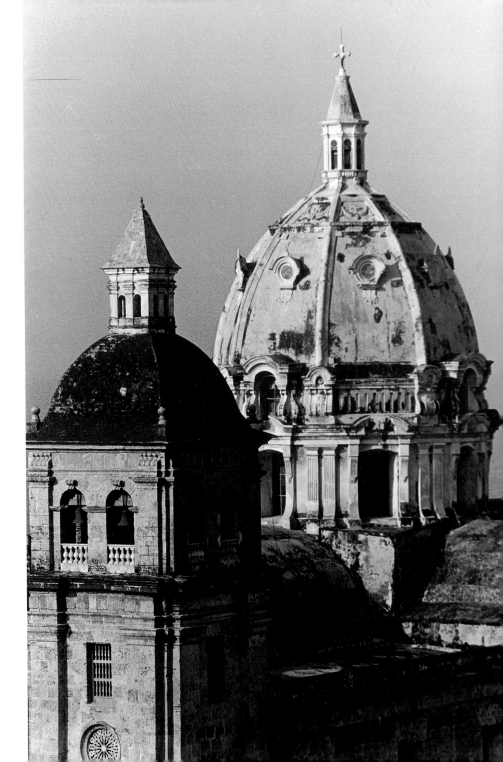

*Dome and spire
of Santo Domingo.*

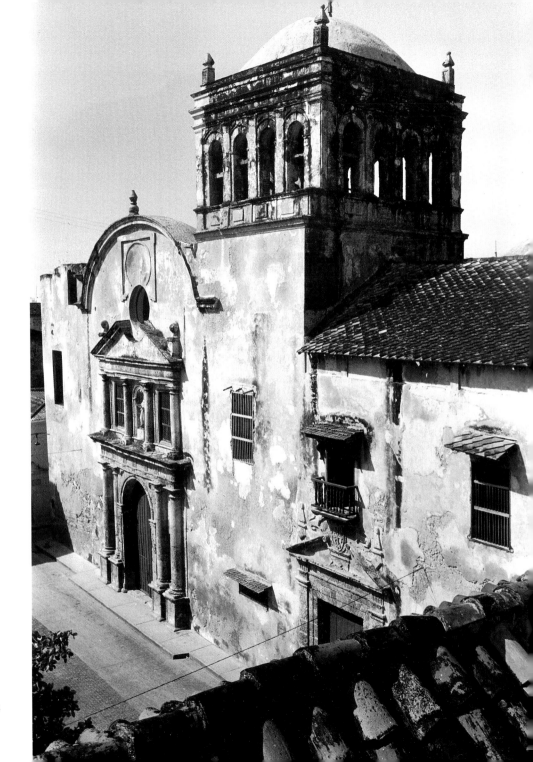

*Church
of Santo Domingo.*

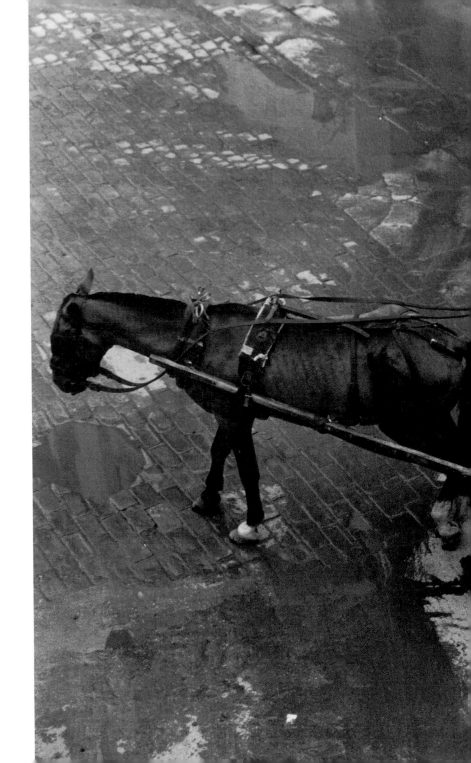

The Cartagena carriage.

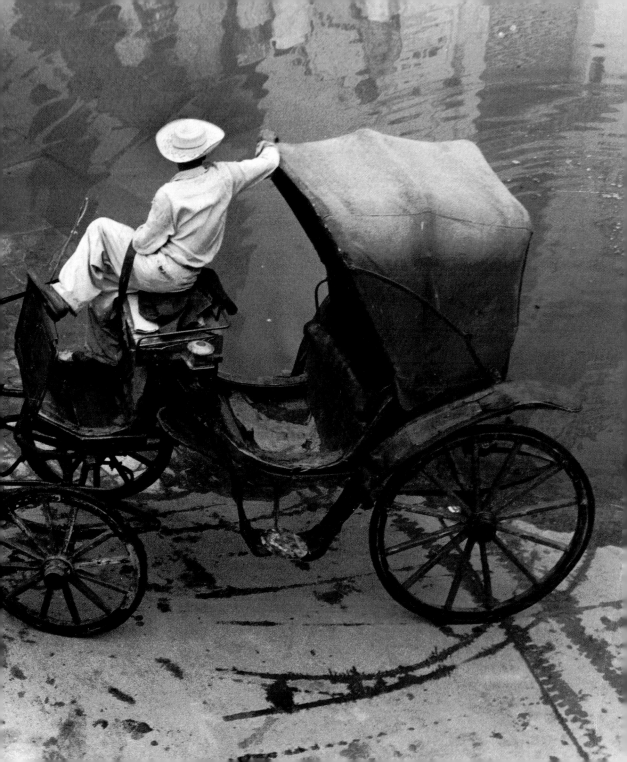

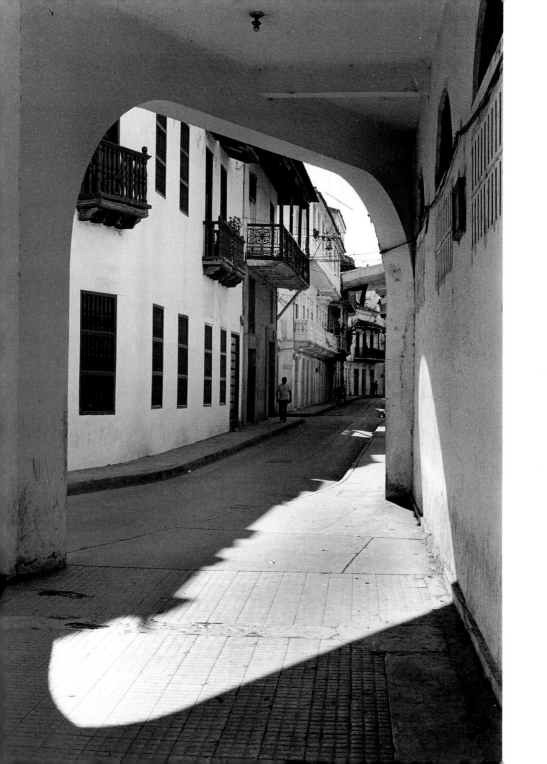

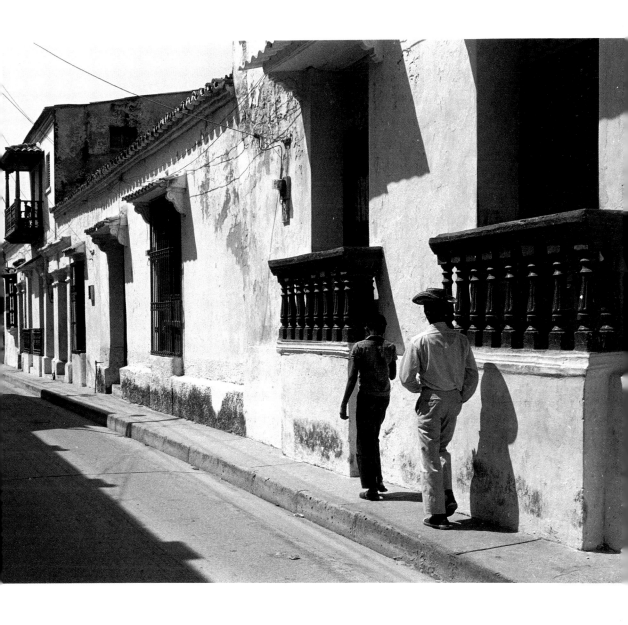

Calle de los Siete Infantes.

Arco de Cabal on Calle de la Amargura.

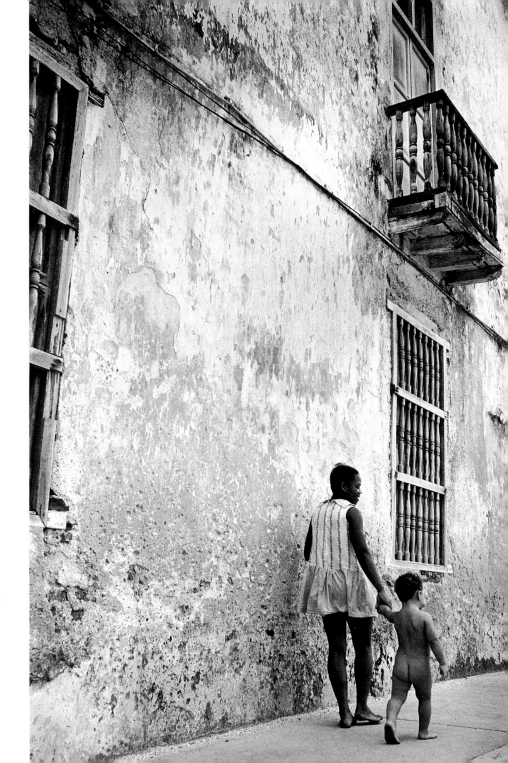

The nanny.

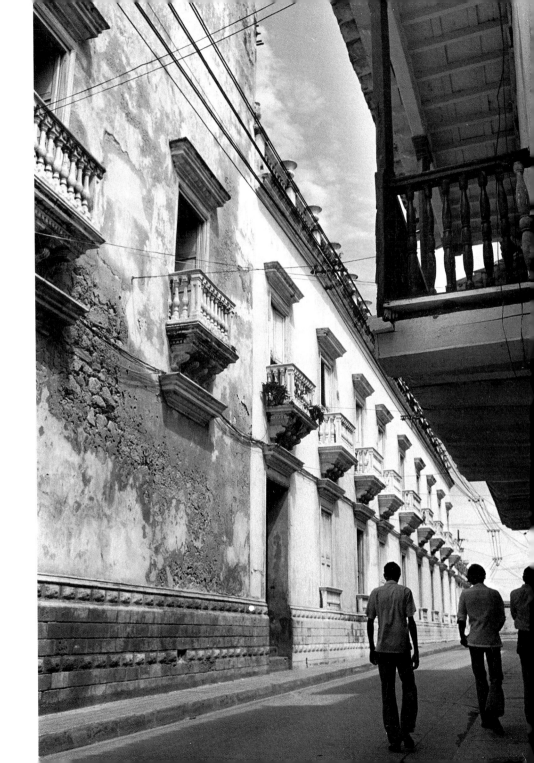

Teatro Heredia
balconies.

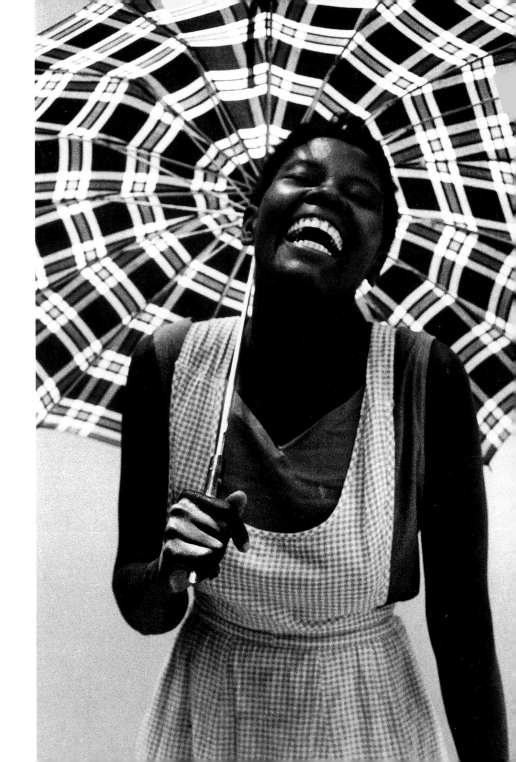

Pérsides.

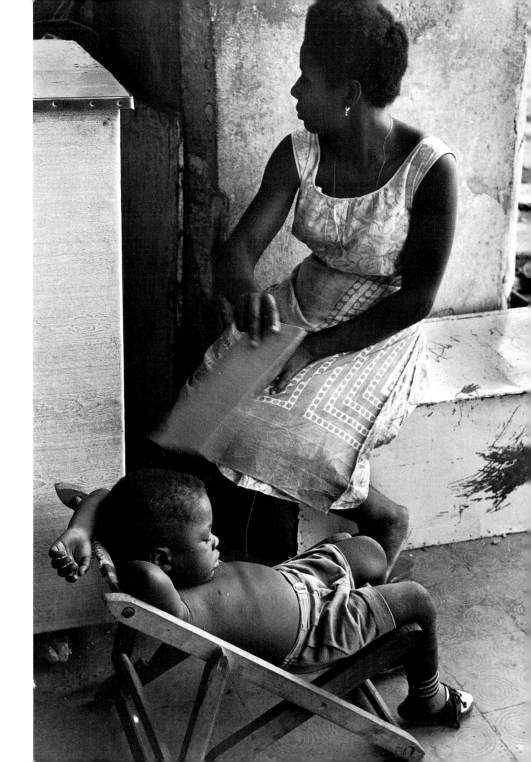

Siesta time.

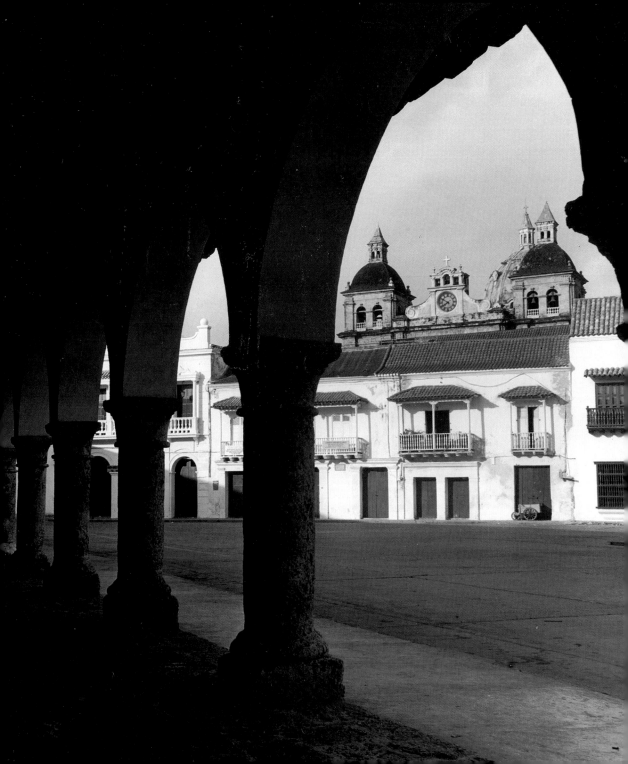

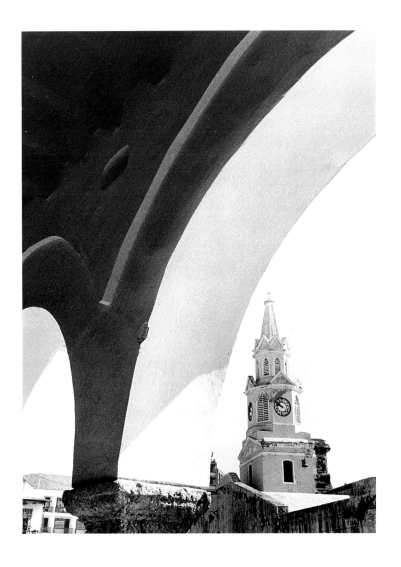

Torre del Reloj.

Torres de San Pedro seen from Gobernación.

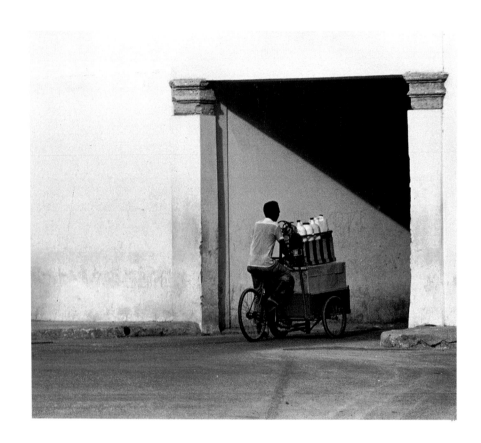

Vendors of raspado (shaved ice flavoured with fruit syrups).

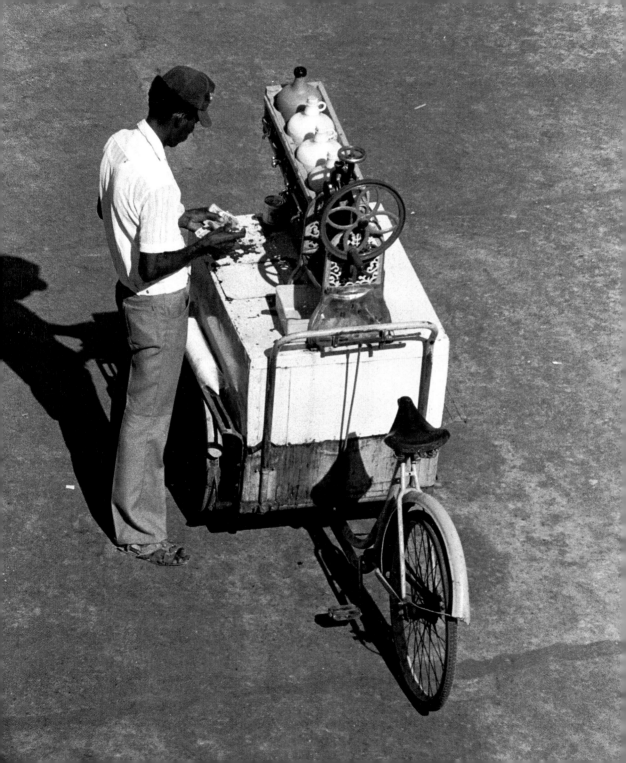

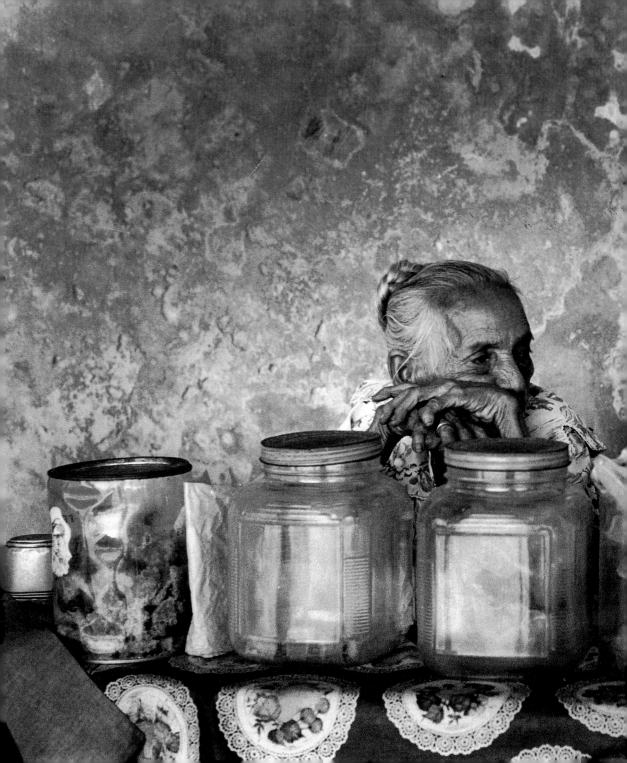

The Porta de los Dulces.

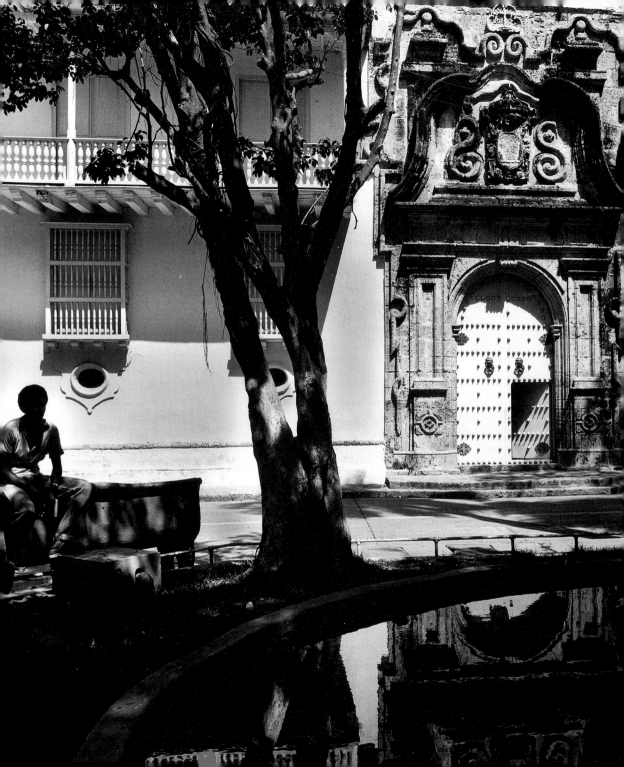

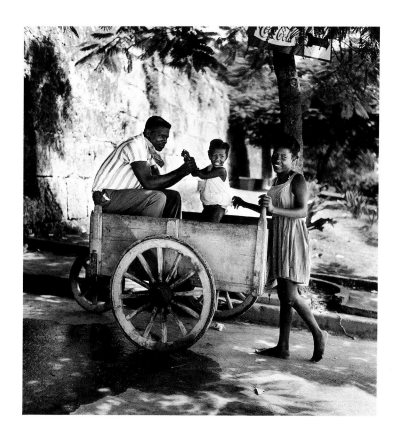

Cart near the fortified walls.

Casa de la Inquisición.

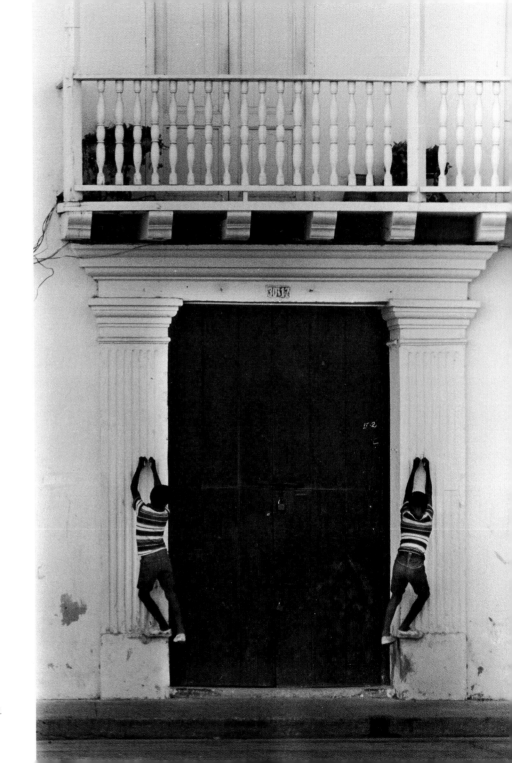

Door with twins.

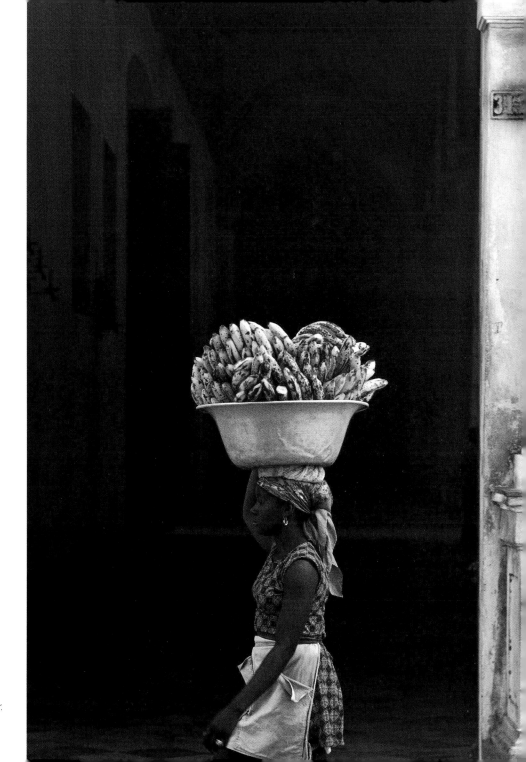

Banana street vendor.

On Calle de los Santos de Piedra.

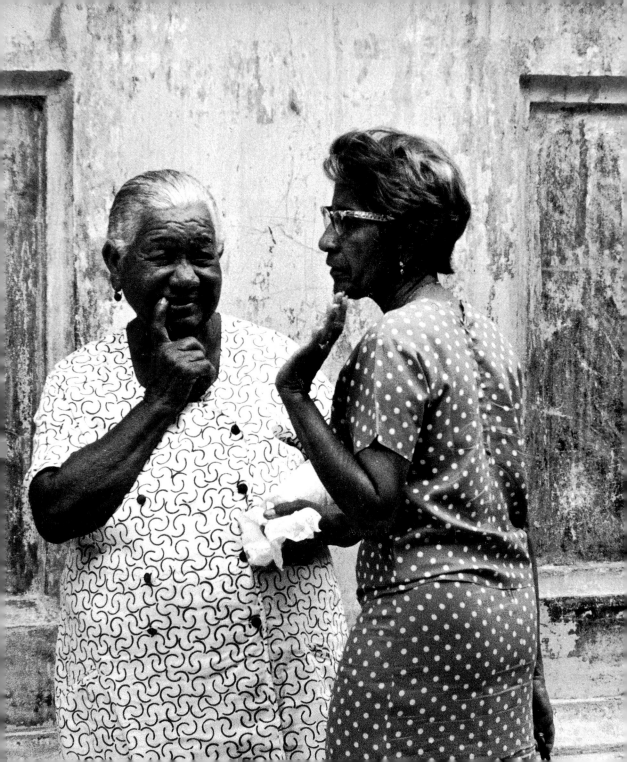

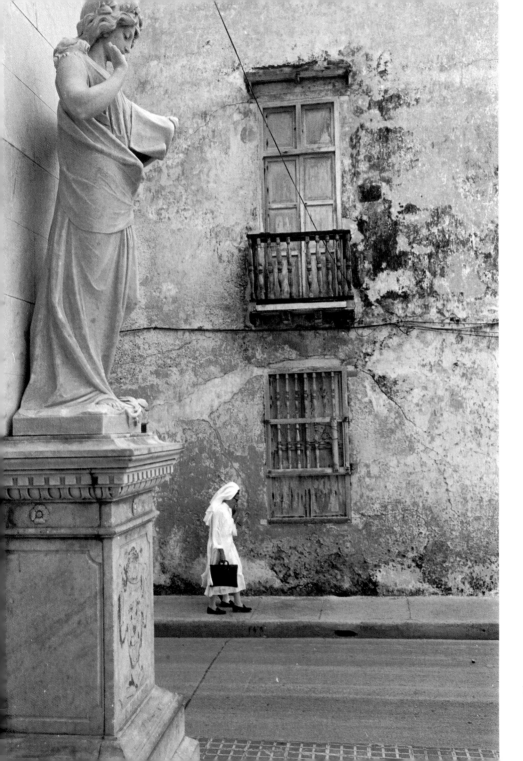

The Muse of Theatre,
Plaza de la Merced.

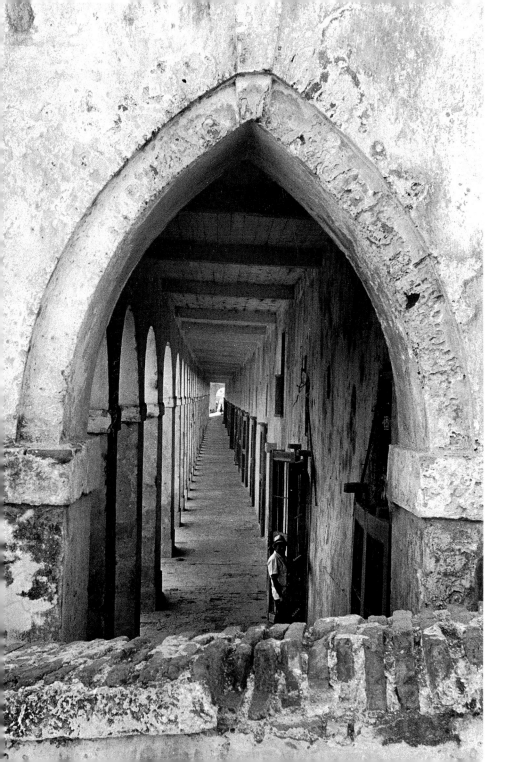

Las Bóvedas.

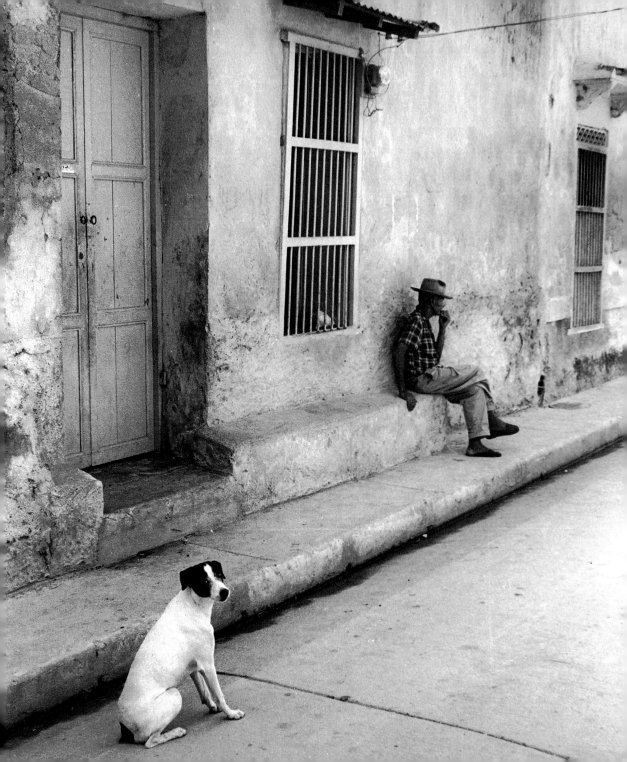

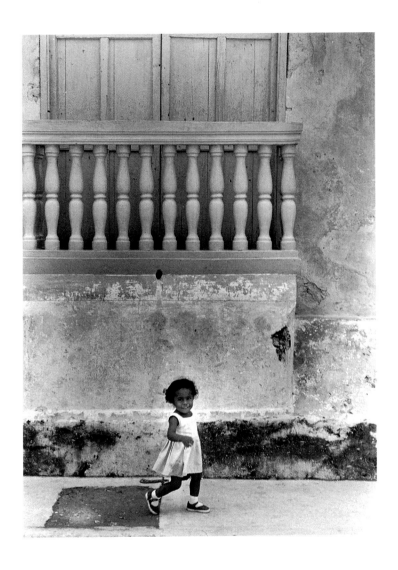

San Diego balcony

Calle del Camposanto.

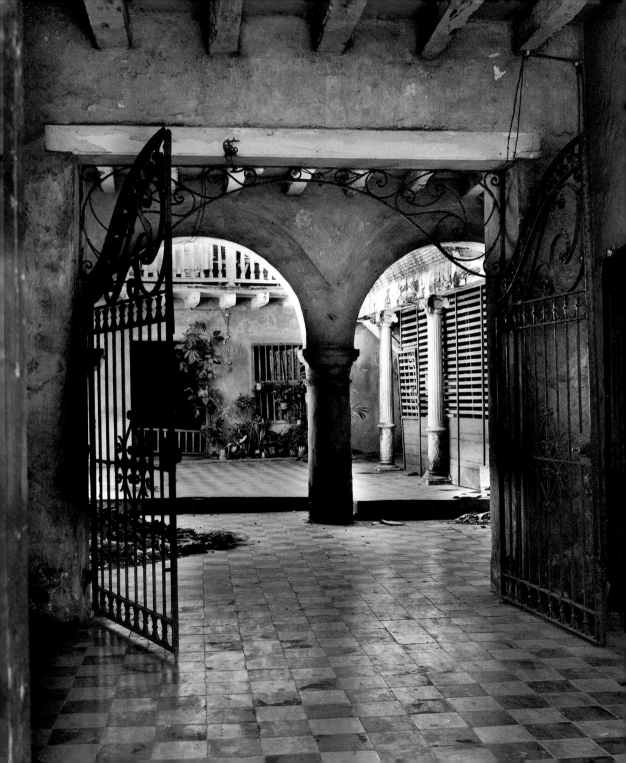

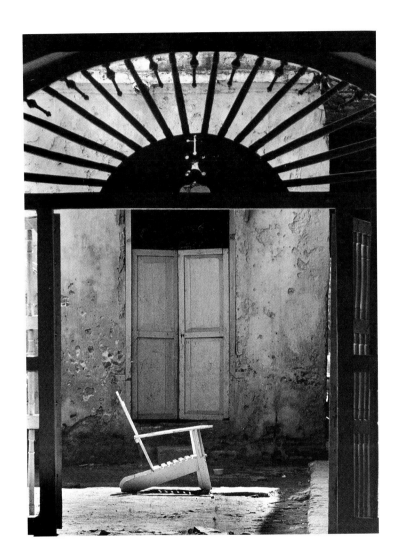

Patios.

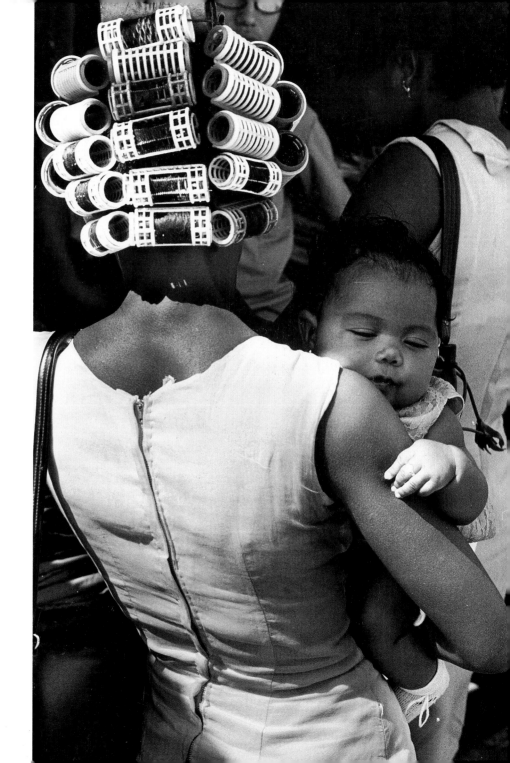

Head of curlers.

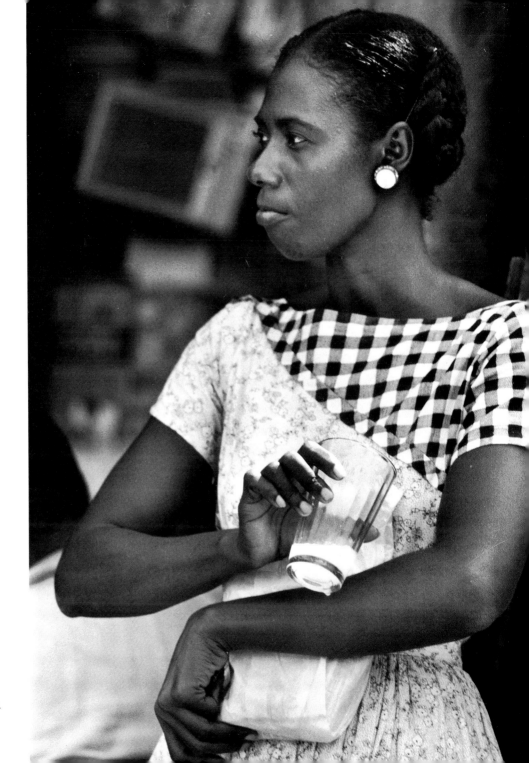

*The glass of
iced oat beverage.*

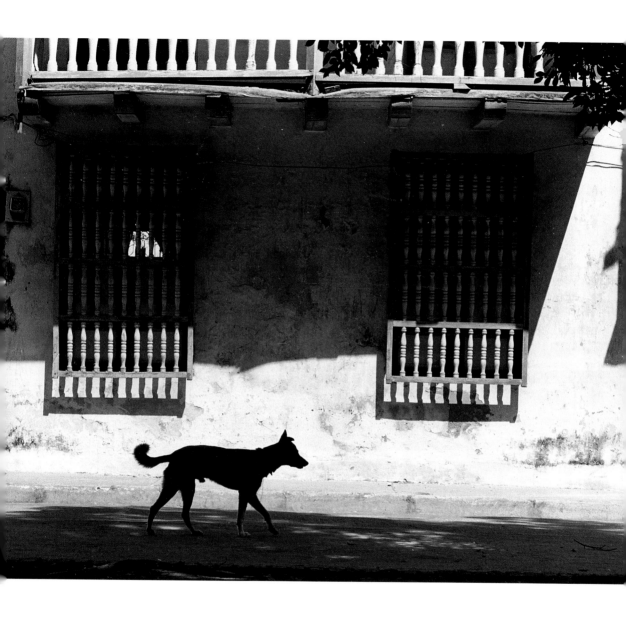

San Diego.

Window on Calle de las Damas.

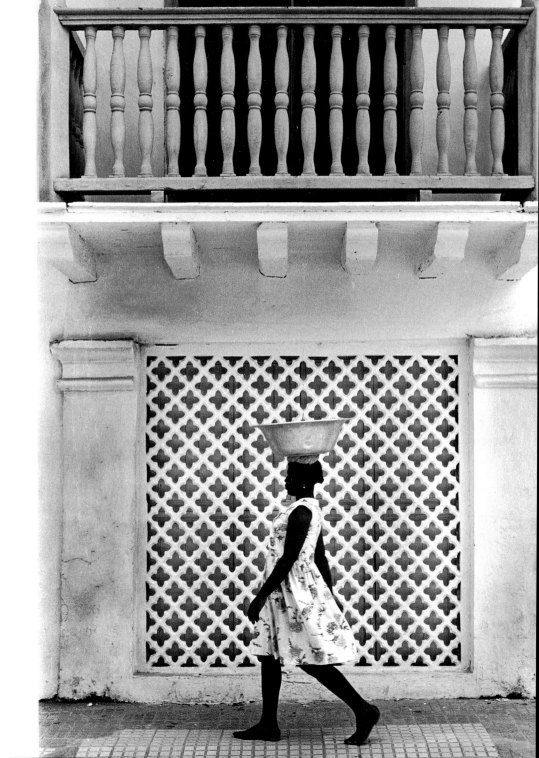

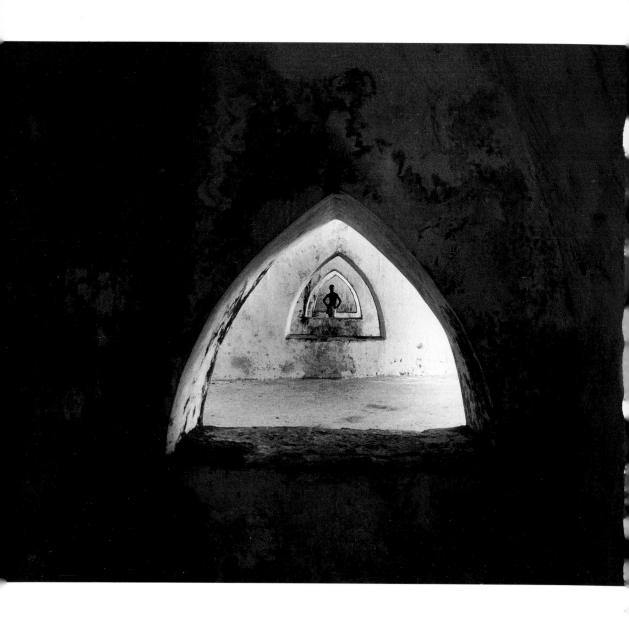

Galeria del Eco, San Fernando de Bocachica.

Zaguán on Calle de Badillo.

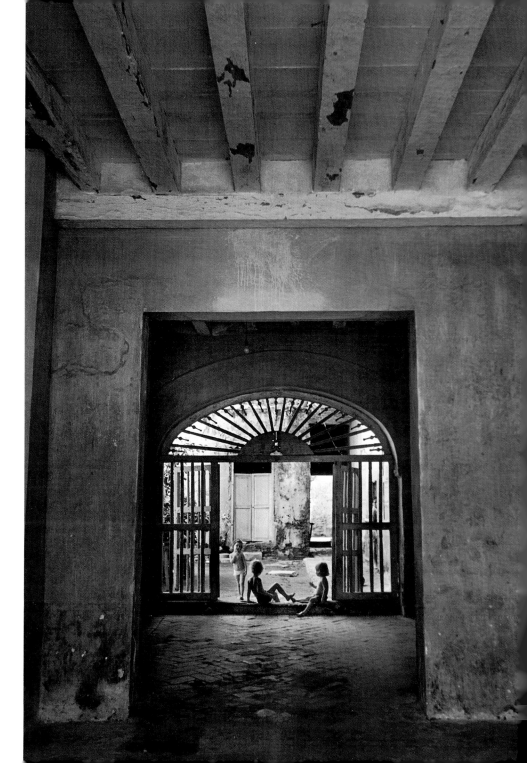

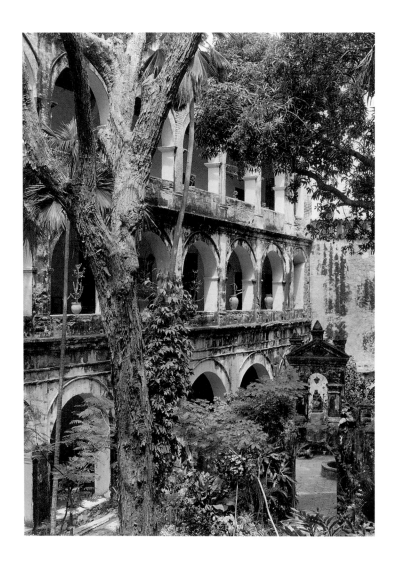

Patio and false gate in the church of San Pedro Claver.

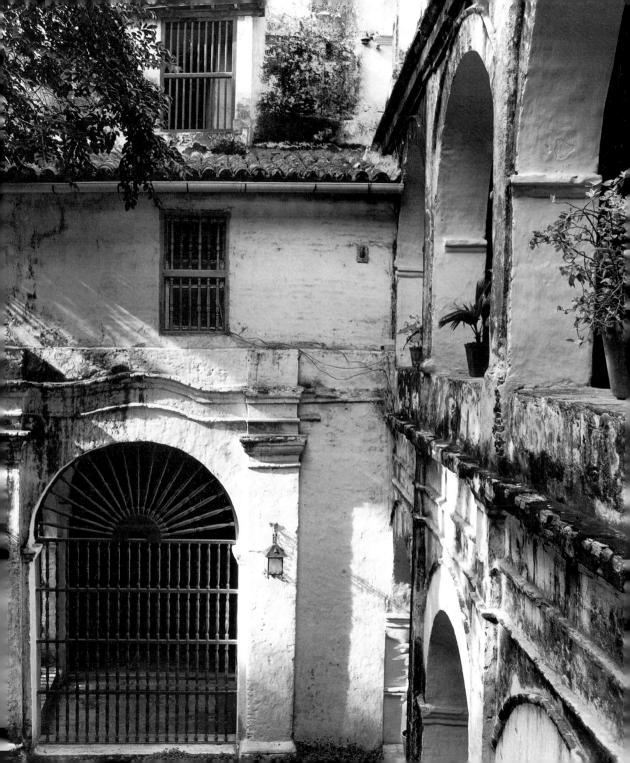

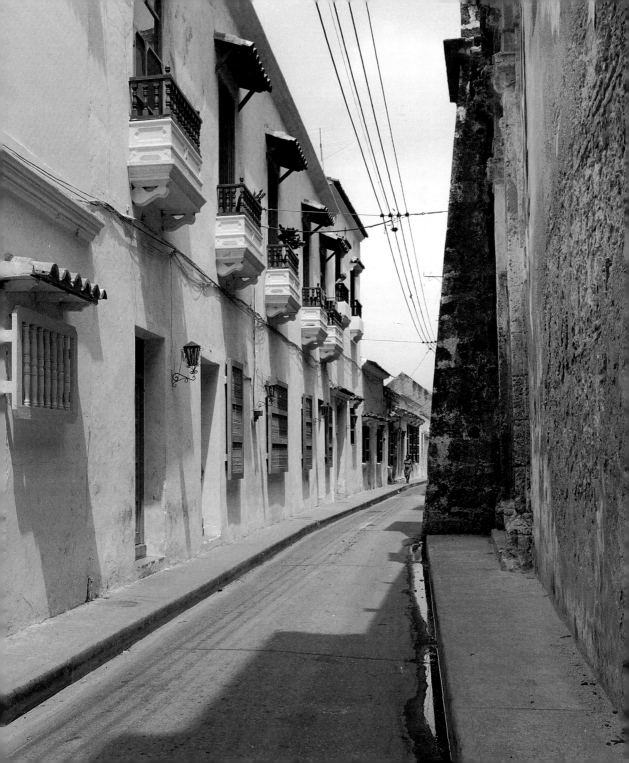

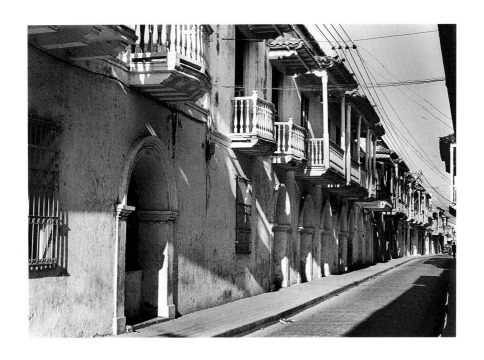

Street.

Callejón del Estribo.

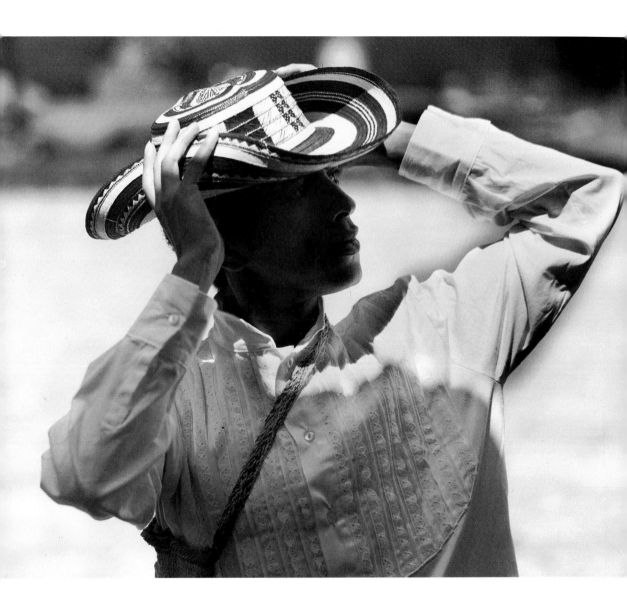

Guayabera and vueltiao sombrero.

Horseman of La Candelaria.

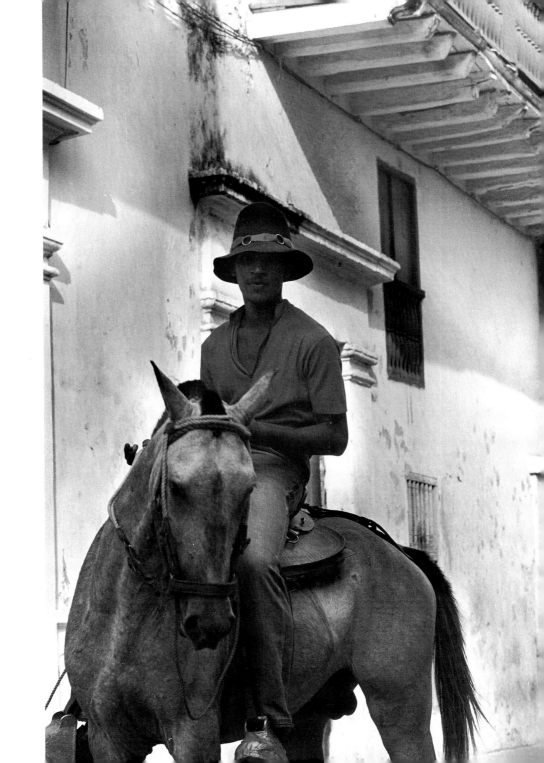

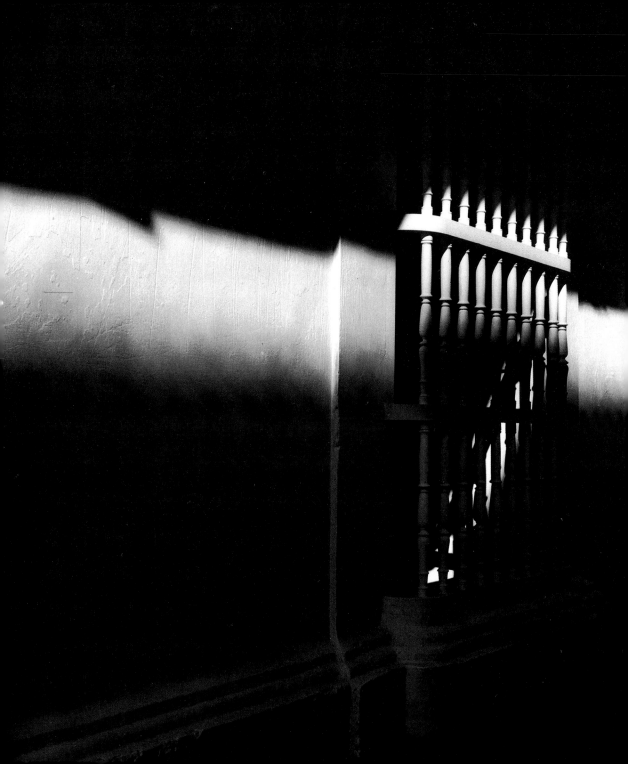

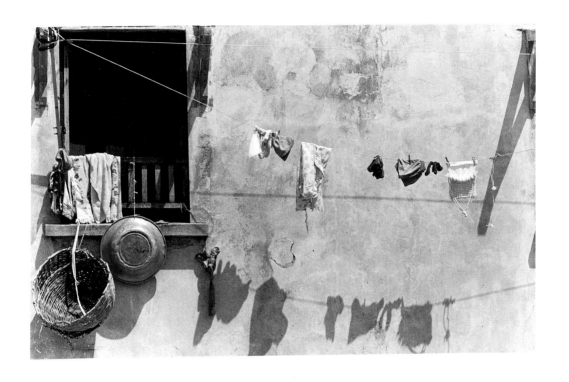

Clothesline.

Ritual of shadows.

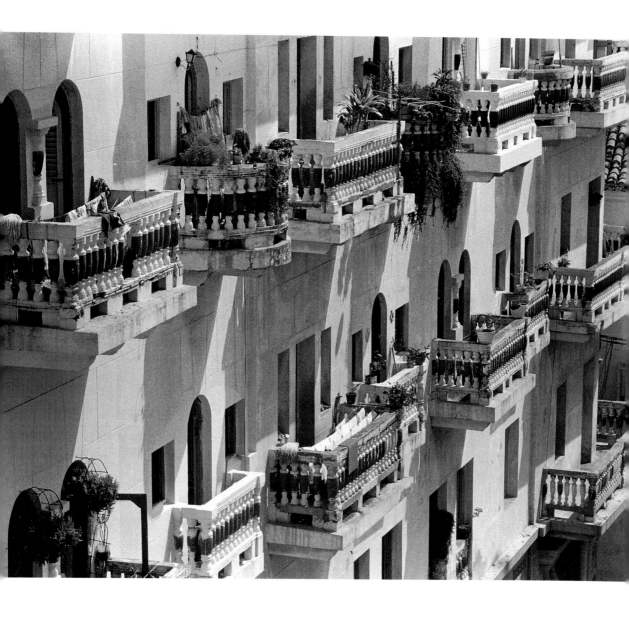

Balconies of Santo Domingo.

Bedroom balcony.

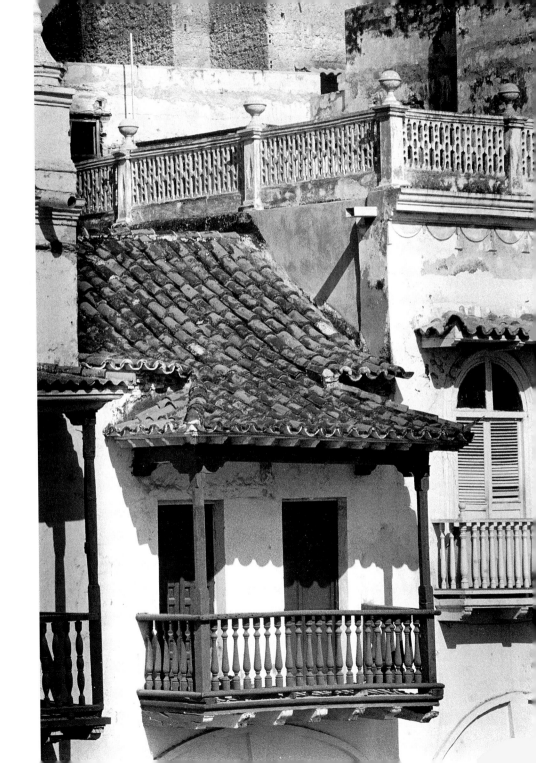

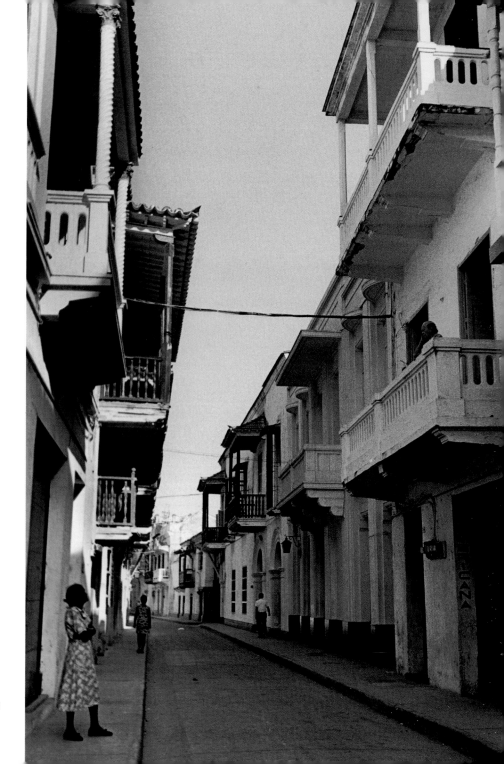

Calling on a balcony.

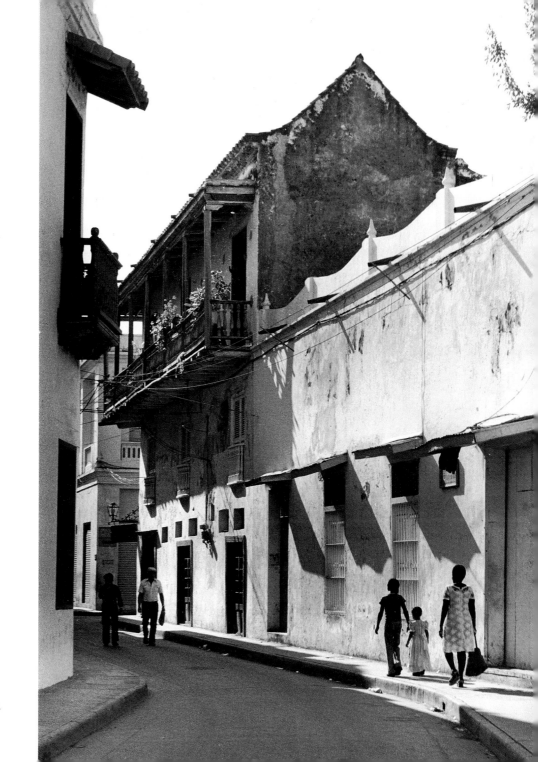

Calle
de la Amargura.

Masts of San Pedro.

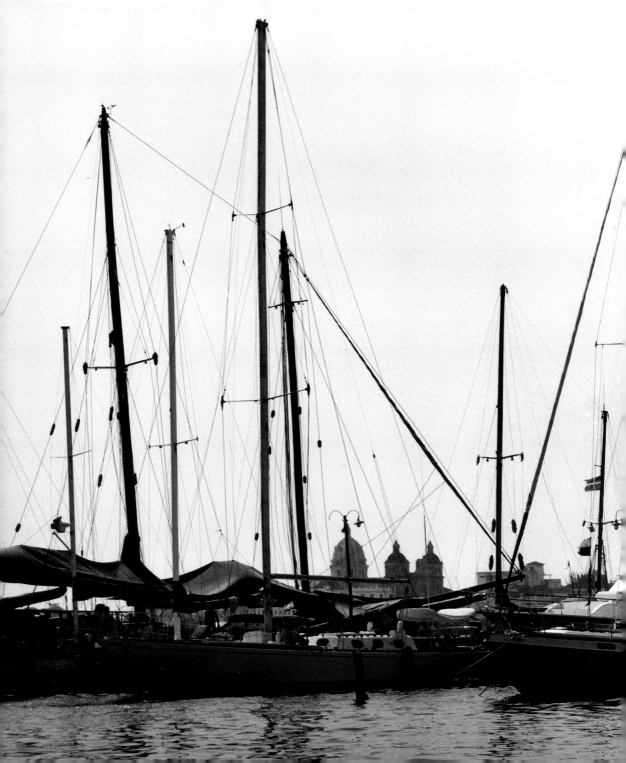

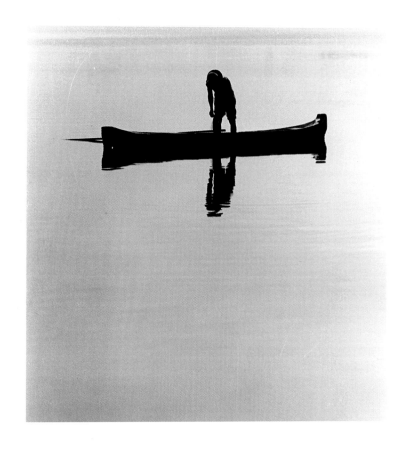

On the Ciénaga de la Virgen.

Caracolillo beach, Bocachica.

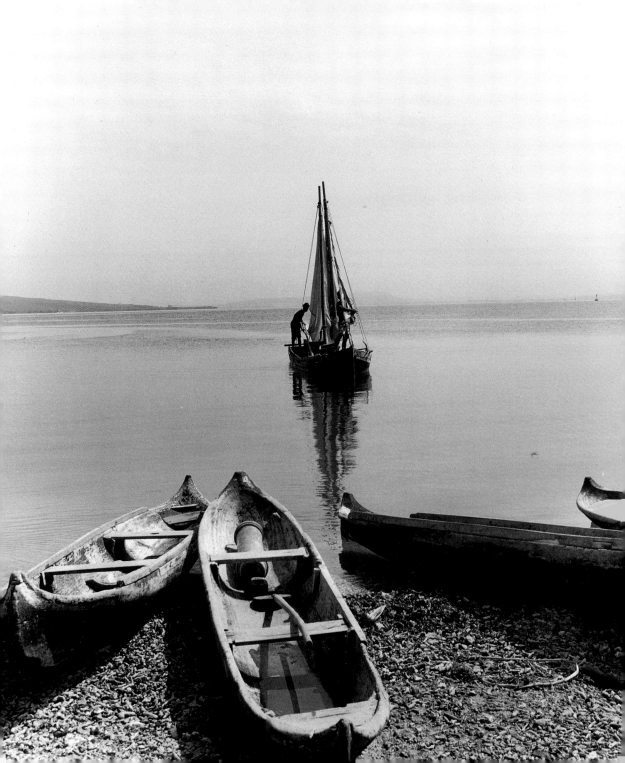

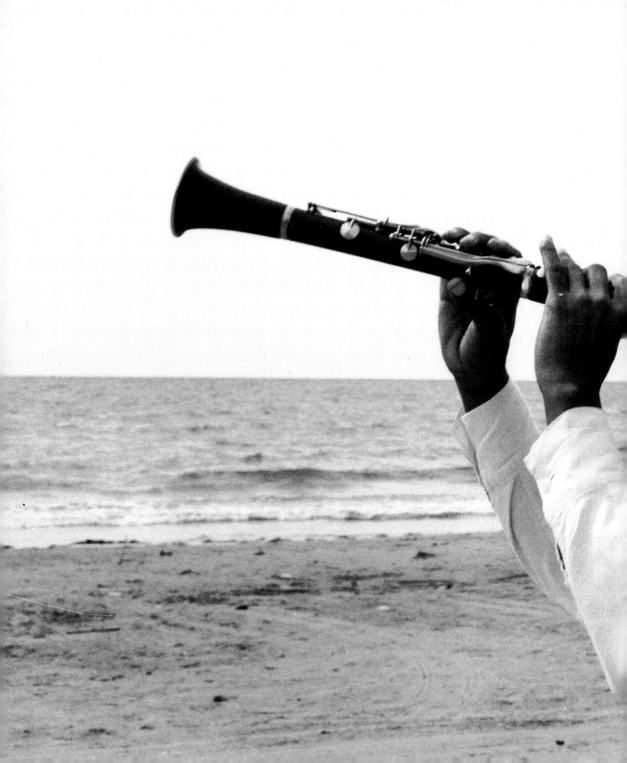

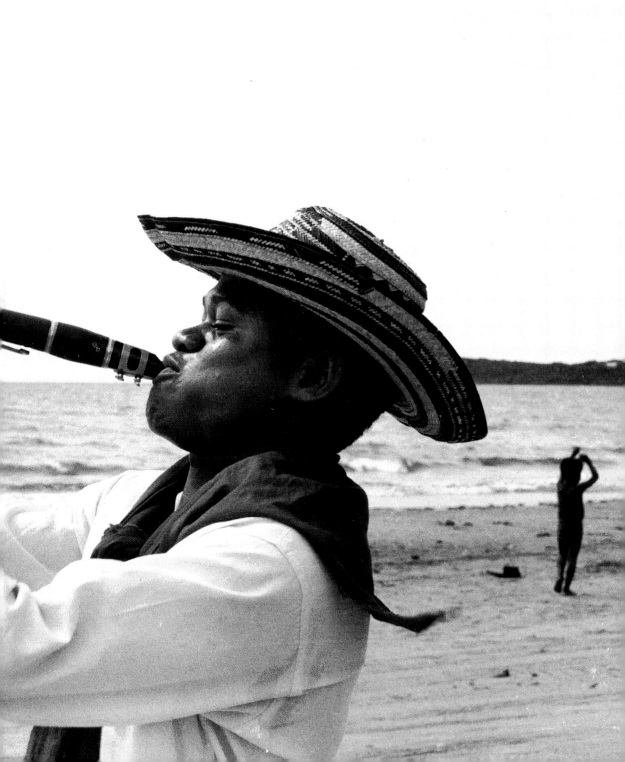